OLD MONEY

Sarah Wooley

OLD MONEY

OBERON BOOKS
LONDON
WWW.OBERONBOOKS.COM

First published in 2012 by Oberon Books Ltd
521 Caledonian Road, London N7 9RH
Tel: +44 (0) 20 7607 3637 / Fax: +44 (0) 20 7607 3629
e-mail: info@oberonbooks.com
www.oberonbooks.com

A catalogue record for this book is available from the British Library.

PB ISBN: 978-1-84943-499-7
Digital ISBN: 978-1-84943-589-5

Cover image by Shaun Webb Design
and Hampstead Theatre

Printed, bound and converted
by CPI Group (UK) Ltd, Croydon, CR0 4YY

Visit www.oberonbooks.com to read more about all our books
and to buy them. You will also find features, author interviews and
news of any author events, and you can sign up for e-newsletters
so that you're always first to hear about our new releases.

Characters

JOYCE

PEARL
Joyce's mother

FIONA
Joyce's daughter

GRAHAM
Fiona's husband

CANDY

MAN ONE

MAN TWO

BAR MAN

WAITER

Man One and Two should be played by the same actor.

Note

Old Money was partly inspired by the Brecht short story
'The unseemly old lady' which was given to me
by the author and director John Burgess when I was working
on an early draft of the play.

The play was written during the global financial crisis of 2008.

Acknowledgements

I'd like to thank John Burgess, Paul Robinson, Raj Shah, Terry
Johnson, Lizzy Abusch, Giles Smart, Alison Chitty, Ashley
Martin Davies and Tim Stark as well as special thanks to Joy
Wilkinson, for all their encouragement and guidance in the
writing of the play.

I'd also like to thank Greg Ripley Duggan, Ed Hall and
everyone at Hampstead Theatre for wanting to produce it.

Thanks also due to Ellouise Moore for her book, *Girl in High
Heels: Intimate Confessions of a London Stripper.*

Old Money was first performed at the Hampstead Theatre on 29 November 2012 with the following cast:

JOYCE	Maureen Lipman
FIONA	Tracy-Ann Oberman
PEARL	Eve Pearce
GRAHAM	Timothy Watson
CANDY	Nadia Clifford
MAN ONE, TWO	Geoffrey Freshwater

Artistic Team

Writer	Sarah Wooley
Director	Terry Johnson
Designer	Tim Shortall
Lighting Designer	Rick Fisher
Sound Designer	John Leonard
Casting	Gabrielle Dawes CDG

SCENE ONE

A funeral 2008.

A (small) congregation in a small Anglican church.

The congregation sings 'Nearer my God to Thee'.

We see JOYCE dressed in nondescript black.

FIONA and husband GRAHAM also dressed in black. GRAHAM a little scruffily.

PEARL smartly dressed in black with hat and veil.

SCENE TWO

A kitchen. In JOYCE's house. PEARL, GRAHAM, JOYCE and FIONA. FIONA, who is visibly pregnant, has just started the process of clearing up.

PEARL Might have known Mary Lomax would be the last to leave.

Did you see her at the buffet?

Filching sandwiches

Stuffing them into her bag

GRAHAM *(To JOYCE.)* Sherry?

JOYCE shakes her head.

PEARL What kind of a woman steals sandwiches at a funeral?

Her handbag was bursting with egg

She didn't even *know* Tony

GRAHAM Sherry, Pearl?

PEARL Not for me thank you

PEARL rummages in her bag.

Gets out an indigestion tablet.

Chews on it.

GRAHAM decides to have the sherry.

Sips it.

PEARL Aw that salmon

Been repeating on me since noon

GRAHAM *(Re. the Sherry.)* This is nice

This is actually rather nice

PEARL Thought we'd get a better turn-out Fiona

I expected more for your father

Hope you're not upset by the numbers

FIONA It's what we expected Granny

PEARL Um?

FIONA Honestly

PEARL Did you put something in the paper Joyce?

Beat.

Joyce?

FIONA I did it

PEARL Eh?

FIONA *I* did it.

PEARL The service was very poor

Didn't you think?

Didn't you think so Graham?

GRAHAM Seemed alright to me

PEARL Should have been longer

More…solemn

I thought he rushed it, the vicar

These young ones they're not up to much

Should have had better hymns too.

Twelve funerals I've been to this year

Twelve and it's only August

Did you see those shoes on the coffin bearer?

Snakeskin

With a buckle!

A *gold* buckle

Where do you imagine you get shoes like that?

Where would you find that sort of thing Graham?

GRAHAM I don't know Pearl

I'm not really up on shoes

PEARL I can see that

GRAHAM looks at his shoes.

FIONA Shall I call you a taxi Granny?

PEARL Not yet dear

Graham can drop me when I'm ready

Did you not want to bring the children?

FIONA They're at school

PEARL You think school's more important than their
grandfather's funeral?

FIONA No, it just…didn't seem appropriate

PEARL They have to know about these things eventually

Death

You can't keep it from them

FIONA They find it hard Granny

Just to sit still it's –

PEARL How old are they now?

FIONA William's eight

Molly's nearly six

PEARL I was four when my mother died

We all went to the funeral

It was expected

She had a horse-drawn carriage

Plumes

It rained all day

My father fell to his knees at the grave

His best trousers covered in mud.

When are you seeing the solicitor?

FIONA Next week

PEARL Who's going?

FIONA Just Mum

We know what he's going to say.

Everything goes to her.

PEARL I'm surprised you want another baby, Fiona

FIONA Well it wasn't planned

PEARL How old are you?

FIONA Forty-two

PEARL You're practically menopausal.

I was nineteen when I had David

Twenty-one with Joyce.

I was exhausted

Every day all on my own, Pappa at sea

Thought to myself, wish I'd stopped at one.

One I could manage

Two it's hard

Three…well you may as well give up!

GRAHAM *(To FIONA.)* We need to think about getting back

PEARL Are you still in that maisonette?

FIONA What?

PEARL The maisonette in Colliers Wood?

FIONA Yes Granny, we're still in Colliers Wood

PEARL I used to know a woman from Colliers Wood

She was a dinner lady

Her daughter told everyone her mother was a
teacher

I wouldn't mind but you'd never mistake this
woman for a teacher

She was definitely a dinner lady.

You could tell by the legs.

How will you fit a baby into that maisonette in
 Colliers Wood?

FIONA Babies are very small Granny

Just teeny tiny things

PEARL You need to move dear that's what you need.

GRAHAM We tried that Granny

PEARL You need to move *quick*!

FIONA We *tried*

GRAHAM Couldn't sell, Pearl

PEARL Well I'm not surprised

Who wants to live in a maisonette in Colliers Wood

FIONA You live in a one-bedroom flat on a dual
 carriageway

It's hardly Cheyne Walk

PEARL Yes but it doesn't matter where I live does it?

I'm old

What you need is a *house*

Nice house in a good area with a garden

Somewhere near your mother

Have you considered Guildford?

GRAHAM We can't *afford* Guildford

PEARL Dorking?

Banstead?

Farleigh?

FIONA Gran

PEARL What about Cobham that's nice

GRAHAM Cobham?!

You're looking at half a million pounds for two
 bedrooms

PEARL Chertsey, Egham, Caterham

GRAHAM OK so she's just naming towns in Surrey now

PEARL Earlswood, Hythe End

GRAHAM She's just randomly naming stops on a train line

PEARL Weybridge

Woking, Walton-on-Thames

FIONA Gran!

PEARL They're all better than London

FIONA All those places

We'd love to live there but

GRAHAM I wouldn't

FIONA Seriously.

We tried to sell, Granny

Really we did but

Nothing's moving

Once things pick up again then

But for the *moment*…

It's not that bad

It's really…not that bad.

PEARL Well, you know your own mind Fiona I'll give you that

Not like your mother

Must have got it from your father

JOYCE suddenly stands up, her hands pressed into the table. She looks like she might scream. But she doesn't. Instead she calmly walks off. Exits.

GRAHAM Joyce?

FIONA *(To GRAHAM.)* You think she's alright?

She's not said a word all day

PEARL Grief…

GRAHAM She'll be alright

PEARL Married forty-odd years

Never a day when they weren't together

Never a night apart

It takes years to get over that.

FIONA I miss him

FIONA sits down. GRAHAM goes to comfort her.

PEARL There there dear, there you go

Let it out let it out.

He wasn't well for a long time dear

And when they get like that then…it's for the best

FIONA I know I know

GRAHAM *(To FIONA.)* You're OK

It'll be OK

PEARL One minute they're watching television or reading a book and they just…cry out

For no reason

Or in the middle of the night they call your name

They know it's the end but they just

Cling on.

I saw it with Frank and I saw it with your father.

I tell you something

When it's my time

I won't hang about

I know when I'm done.

GRAHAM Is it time for that lift now Pearl?

Beat.

PEARL I think it's time for that sherry.

SCENE THREE

FIONA and GRAHAM's flat. A few weeks later. GRAHAM watching TV. Guitar on his lap. FIONA enters.

FIONA Hello

GRAHAM Hey

FIONA I'm not stopping

What you doing here?

She goes out, picks up another pair of shoes, trainers.

GRAHAM You picking up the kids?

FIONA *(Off.)* Yeah my day today, usual rush

So much easier when Mum does it.

I think that's all working now, that?

Don't you?

GRAHAM What's working?

FIONA The kids, Mum picking them up, instead of the after school club

GRAHAM Oh. Yeah. Yeah it is

Loads better

She re-enters. Changes into the trainers.

FIONA I know it's not every day

GRAHAM No

FIONA Still use the club those other days

And it's more out of the way for Mum

Bit of a round trip for her but it's good, good for her

It's better

Don't you think?

GRAHAM Sure

FIONA Means they're not at school all day

That they have someone who cares or

Just to make sure they eat, do homework

Family

Don't you think?

GRAHAM She feeds them?

FIONA Dinner after school, yeah

You knew that

GRAHAM I did.

FIONA And it gives Mum something to do doesn't it?

GRAHAM It does

FIONA 'Cause I was thinking

When Dad died Mum probably thought

What's my purpose?

What's the point of getting up in the morning now
he's not here?

GRAHAM Yeah

FIONA And all that time he was so ill and she looked after him

Now there must just be this…void

GRAHAM Void?

FIONA Yeah

A huge hole

A huge hollow hole that needs filling

'Cause you have to do something with your day
don't you?

Otherwise you go mad.

Shoes are changed.

GRAHAM watches TV.

FIONA I went to my appointment.

GRAHAM What appointment?

FIONA Antenatal

GRAHAM Was that today?

FIONA Yeah

GRAHAM How was it?

FIONA OK

Pause.

They don't seem that bothered

GRAHAM Bothered about what?

FIONA My age

GRAHAM Well, we've had two already so

FIONA Yes that's what I thought

Even so when Joanne was pregnant

The midwives

Well they were really on it

She had loads of scans

GRAHAM Well that's Joanne

FIONA Sorry?

GRAHAM Joanne

She's quite…demanding isn't she?

FIONA Is she?

GRAHAM Big time

Pause.

What?

FIONA Nothing

Pause.

GRAHAM *What?*

FIONA I don't think Joanne's demanding

GRAHAM Oh she is

FIONA She isn't

I think…

I just think her hospital's better than ours

GRAHAM No.

They're all the same

FIONA No they're not.

We did say Graham, didn't we?

After Molly

We did say we'd never go back to that hospital again

Not ever

GRAHAM We didn't think we'd have any more kids then

FIONA True but

GRAHAM You know you can go to any hospital you want

You can *choose*

FIONA Within *reason*

GRAHAM Yes obviously

You're not gonna go all the way to Barnet

FIONA Obviously.

He goes back to the telly.

Pause.

FIONA Can we

Definitely

Not afford to go private?

GRAHAM Private what?

FIONA Hospital

For the birth 'cause I was thinking

GRAHAM What?

FIONA A private hospital

Is it definitely not an option?

GRAHAM No!

God no it's not an option

FIONA OK sorry

GRAHAM Bloody hell Fi!

FIONA What?

GRAHAM Well where's…

A private *hospital*?!

FIONA I know it's just

 Last time

GRAHAM Last time

 It won't *be* like last time

FIONA I nearly died Graham

GRAHAM No you didn't

FIONA I think I did

GRAHAM A private hospital

 Do you know how much they cost?

FIONA No you're right, you're right, go to Argos get me a paddling pool

 I'll bleed to death right here in the living room.

GRAHAM You do not need to go to a private hospital

 You're not

 Liz Hurley

FIONA No.

 But I'd still like to look into it.

 For peace of mind.

 Beat.

 She turns to leave. Stops.

 He watches TV.

 What you doing here by the way?

 It's only three o'clock…

SCENE FOUR

PEARL's house. A month later. PEARL is sitting reading the Daily Mail. *JOYCE is sitting opposite, drinking tea. They don't talk as PEARL carefully turns the pages in her paper. Eventually:*

PEARL It's come out about him then

 The one that's married to her…footballer

She reads.

Turns a page.

Never trust a man with piggy eyes…

JOYCE sips her tea.

PEARL reads.

Turns a page.

Gordon Brown…

Pause.

Now, there's a man in trouble…

Turns page.

Oh here we go

Nick Clegg…

'One day I'll be prime minister'

I don't think so dear…

Turns a page.

She shows JOYCE the paper.

See him?

That one

He does the comedy on BBC 2…never liked him

Points to a man.

Do you think he's a homosexual?

JOYCE looks at the photo.

He looks like one from here.

Studies the picture of the man.

Turns a page.

Reads.

Coughs again.

Turns to the back page.

I only buy it for the racing.

JOYCE stands up.

JOYCE Better go

PEARL You rushing off?

JOYCE puts her coat on.

JOYCE Shall I feed the cat?

PEARL New coat

JOYCE What?

PEARL Coat

It's new.

Didn't notice that when you came in

JOYCE looks down at her coat. Strokes it. She loves it.

JOYCE Didn't you?

PEARL When you get that?

JOYCE Last week

First time I've worn it

PEARL It's a bit young

JOYCE What?

PEARL Bit young, for you

I'd have thought

Your age

You'd be drawn to something a bit more…classic

Something in navy or camel

JOYCE I wanted this one

PEARL It's red

JOYCE I know.

Pause.

Do you want me to feed the cat?

PEARL Yes please.

Give him the wet stuff

JOYCE *(The smell.)* Do I have to?

PEARL Well he won't touch the dried

And his litter needs changing…

JOYCE moves to go.

The thought of wet cat food and litter on her mind.

Before you go.

I've got something to say.

JOYCE Well that makes a change

PEARL I've been having a think…

I want to visit the grave.

I'll need transport

You'll have to take me

JOYCE I don't need to take you

It's just down the road

PEARL Not Pappa's grave

Tony's grave

Man's been dead a month and I've not been

JOYCE Bit far

PEARL What?

JOYCE It's a bit *far*.

Least it felt far at the funeral…

PEARL How long does it take from your house?

JOYCE I don't know

PEARL You must know

JOYCE I don't.

PEARL You have…*been* to Tony's grave haven't you?

You have visited?

Taken flowers?

JOYCE Since he was buried?

PEARL Yes since he was buried

JOYCE No, I've not.

I've not been.

Beat.

PEARL Good God Joyce!

Well that's not right

Who's been looking after him all this time?

JOYCE It's only been a couple of months

PEARL Headstone could be vandalised by now

JOYCE It won't be

PEARL Could be in a right state

JOYCE Mother!

PEARL You don't read the papers

There's yobs out there

Ferals

Kids like rats

JOYCE In graveyards?

PEARL *Yes*

That's exactly where they'll be.

Smoking crack, having sex and vandalizing grave
stones…

JOYCE All at the same time?

PEARL We'll go tomorrow.

When you come tomorrow, come early

JOYCE No

PEARL No?

JOYCE I can't

I've got something else on

PEARL Like what?

Beat

JOYCE The opera

PEARL The opera?!

JOYCE Yes!

PEARL The opera doesn't come to *Cheam*

JOYCE No.

I'm going into town

London

They have a matinee I can get a standby

I fancy going

I saw a poster on the tube for it

PEARL You what?!

JOYCE I went to a concert last week

Saw a man on the harpsichord

I'd never even seen a harpsichord

Let alone heard someone play it

It was marvellous

And you get money off, senior rates.

PEARL You mean you'd rather go all the way into London
to the opera than

Visit your husbands grave!?

JOYCE Yes.

Yes I would.

PEARL Well now I've heard it all.

JOYCE Why d'you say, 'all the way into London?'

You've always said that

We live in Surrey!

It's thirty minutes.

Half an hour on a train

When I was a kid I thought London was the other
side of the world way you used to go on.

When I was at school I used to stare at the railway
station from the window of Room 3 and dream

PEARL I bet

Spent the last forty-odd years staring out of
 windows

JOYCE I used to imagine catching a train

And it would keep going and going and going

Till my feet were on Waterloo Bridge.

Beat.

Why did we move?

PEARL There was a war on!

JOYCE Yes, but *after*

We could have gone back

PEARL You don't want kids growing up in London Joyce

Too many temptations, bright lights

JOYCE I love bright lights!

PEARL Yes.

We know that.

Pause.

She's worn out.

Tomorrow morning you go to Asda by the
 roundabout

First thing, get me some blooms

I don't want to hear anything more about opera or

whatever adventures you think you're having Joyce
 Poole

JOYCE I haven't been Joyce Poole since 1963.

PEARL Tomorrow

We'll go to Tony's grave

JOYCE No.

PEARL Yes.

After that we make it a regular thing

Every Wednesday you come here and we'll pay our
 respects

God knows the poor man deserves it.

Beat.

And you can leave the red coat at home.

SCENE FIVE

A park bench, Regent's Park. A week later. Afternoon. JOYCE sits on the bench. She is still wearing her coat. A MAN enters. He sits down next to JOYCE. After a while.

MAN Just sitting?

Pause.

Just…thinking…are we?

JOYCE I wasn't, actually

No

I was just

MAN Letting your mind wander…

Well you get to our age don't you

JOYCE Our age?

MAN Yes.

Beat.

You've earned the right to just

Sit

Sit and let your mind wander

Don't you think?

JOYCE I…

Yes

Suppose so

MAN You like this park?

JOYCE What's that?

MAN The park

Regent's Park?

I prefer Hyde Park

Or even St James's

But this place is good for me

It's local.

I live across the road

You can see this bench from my window

Beat.

Sorry

I'm going in a minute

Leave you to your –

JOYCE Which one?

MAN Pardon?

JOYCE Which one is your house?

Beat.

MAN That one.

Just there

Number

It's

Right in the middle

I can see all the comings and goings from there

In the morning, people going to work

Then the children, school and in the summer,
tourists

They wander up from the waxworks on the way to
the zoo.

JOYCE Must get busy

MAN Yes

But I like busy

Keeps my mind occupied.

Pause.

Do you?

Like busy?

Being busy?

JOYCE Depends…

I like being busy if I've chosen to be busy but

Other people

Expecting you

Wanting you to

I don't like that.

Pause.

Do you like my coat?

MAN Your

JOYCE Coat?

Do you like it?

MAN It's red

JOYCE I know.

Pause.

MAN Would you mind

Standing up

I could see it better then

Get a better look

JOYCE stands up.

MAN Now turn round

She does. MAN takes a long look. She turns round.

JOYCE Well?

MAN I love it!

JOYCE You do?

MAN Yes

You look

Charming!

JOYCE Oh

MAN What a fine coat

JOYCE That's what I thought.

When I first saw it

MAN Yes I bet

JOYCE I thought

quality I

I tried it on

I thought it's red

You never normally wear red Joyce but

I think

I think it really suits me

MAN It does

JOYCE Didn't go to the usual place

Usually I go to Debenhams or Marks

But this time I

I went to Bond Street.

MAN Quite right

JOYCE I don't know what came over me

I thought it's time I went a bit more upmarket

Spent a bit more

I've got the money

What's the point of just making do?

MAN Yes

JOYCE And it's not like I need to

Never had to need to so why not

MAN Yes

We all need to be encouraged, sometimes, to just…

throw caution to the wind

JOYCE My daughter, she sees something she likes she just
goes for it

Doesn't worry

If she wants it she says I'll have it.

MAN Well she's young

JOYCE Oh I'm so glad you like it

MAN Like it?

You look sensational!

JOYCE Thank you.

You come here often?

MAN To the park?

JOYCE To the bench?

Beat.

MAN Every Tuesday and Thursday

Usually between one and two

JOYCE That's very regular?

MAN My wife she

JOYCE Wife?

MAN Yes.

Those are the days she spends with her carer

Respite

She

JOYCE Oh she's

MAN Sick.

Yes.

It's been a long…

Started with her memory and now

JOYCE I see

MAN Yes.

JOYCE What time is it?

MAN Nearly two

JOYCE I have to go

Colliers Wood

My grandchildren

MAN You look after them?

JOYCE Yes

After school

Three times a week

It's my daughter's idea

MAN Well it gets you out the house

JOYCE Yes.

Yes it does

Sorry I have to go

MAN Never stops does it?

JOYCE No.

MAN It was nice to meet you

JOYCE And you

MAN I enjoyed our talk

JOYCE Me too

MAN And you do look

So very lovely in that coat.

Pause.

Will you come again?

I'm here Tuesdays and Thursdays between

JOYCE One and two

Yes, you said…

MAN My house…

It's just across the road.

My wife she's not really aware of…so

JOYCE I'm sorry.

I should go

MAN Is it your husband…?

Pause.

JOYCE No

No

He's dead.

Pause.

It was nice to meet you

to talk to you.

It's been a long time

Pause.

She doesn't move.

A moment.

Then suddenly she moves.

JOYCE Bye then

MAN Goodbye

She's gone.

SCENE SIX

FIONA's a few hours later.

FIONA Did you give them dinner?

JOYCE I gave William the pasta and Molly the chicken
 but she didn't want that so she had cereal

FIONA Breakfast cereal?

JOYCE Yes

FIONA Which one?

JOYCE I don't know

Whatever's there.

Rice Crispies?

FIONA That's not enough

JOYCE I did try.

It won't hurt to miss dinner once in a while will it?

FIONA Except she's done that already this week.

JOYCE Has she?

Beat.

FIONA It doesn't matter

Beat.

FIONA Did William do his homework by any chance?

JOYCE What?

FIONA William?

Homework?

Did you see him doing it?

JOYCE I think so

FIONA You can't remember?

JOYCE They both sat down for a bit.

Could that have been homework?

FIONA You didn't check?

JOYCE No.

Was I supposed to?

FIONA No no

It's just

the school don't

It doesn't matter

JOYCE I picked up Graham's prescription

Graham's pills

FIONA Oh, thank you

JOYCE They're on the kitchen table

FIONA Great.

JOYCE How's the

Job hunting?

FIONA He's looking

He's out there looking

JOYCE Well that's something

FIONA He knows now that quitting was a mistake

And in the meantime he's working on his own stuff

JOYCE Music?

FIONA Yep.

Well, he still has his contacts from his days in the band so hopefully

JOYCE Oh the band

Whatever happened to the band?

FIONA Trevor's got a job in marketing, Mike moved to Burnley and Dan's a bin man.

Mum, I need to ask you something

JOYCE I met a man today.

FIONA A man?

JOYCE In Regent's Park

FIONA What were you doing in Regent's Park ?

JOYCE Just

Wandering

I've never been before

FIONA Haven't you?

JOYCE No

Don't you think that's a disgrace?

FIONA What's a disgrace?

JOYCE That I've never been to Regent's Park

All these years

I could have gone

I should have gone before

FIONA I suppose…

JOYCE Do you take the children?

FIONA To Regent's Park?

JOYCE Yes

FIONA No

It's

In North London isn't it?

JOYCE You should

It really is one of the prettiest

It's got a band stand

FIONA Has it?

JOYCE Yes and a zoo and lots of little, you know

Private

The planting

Flowers are nice

FIONA So this…man?

JOYCE What man?

FIONA The man you met in the park

JOYCE Oh yes

FIONA What was he like?

JOYCE Nice…

He was nice.

FIONA And is this someone you might…

JOYCE Oh

No

No

FIONA Because I was going to say

JOYCE Oh no no no don't worry

FIONA 'Cause it's a bit soon isn't it

JOYCE Yes yes no

FIONA And a man in a park well

JOYCE Yes you're right

I just…wanted to tell you I'd been to the Regent's
Park.

That's all.

I better go

JOYCE puts her coat on.

FIONA I need to borrow some money.

JOYCE What again?

FIONA Yes

I know but

We're desperate.

We're really

JOYCE How much?

FIONA Two thousand

JOYCE Two?

GRAHAM enters.

GRAHAM Hello

FIONA Hi

Beat.

(To GRAHAM.) Any luck?

GRAHAM Not really

Beat.

Hello Joyce

JOYCE Hello dear

GRAHAM Everything alright?

FIONA Yes yes

JOYCE I'm just off

FIONA I'll give you a lift to the station?

JOYCE No, it's fine I can walk

GRAHAM Nice coat Joyce

JOYCE What?

GRAHAM Coat.

Is it new?

JOYCE Yes

GRAHAM Suits you

JOYCE Thank you

GRAHAM Where'd you get it?

JOYCE Oh the usual, I think

Marks

I don't really remember

GRAHAM Very smart

Isn't it Fi?

Smart

FIONA Yes

GRAHAM Look smashing in that Joyce

JOYCE Thank you

GRAHAM And how were the *beasts* today?

JOYCE Who?

GRAHAM The *beasts*

FIONA He means the kids

GRAHAM Did they behave?

JOYCE They were good

GRAHAM I don't believe you

You know…lately

I don't know if it's an age thing or

But they're at it all the time

Fighting, whinging, screaming

Don't you think?

JOYCE Erm

GRAHAM I thought they'd have grown out of it by now

JOYCE Well

GRAHAM You see Fiona, she's brilliant with them

She has the knack you see

FIONA Well if you spent more time with them Graham

You'd get the knack too.

GRAHAM I lose my patience

The other night…

Molly

She woke up in the middle of the night

Wouldn't go back to sleep and I

I went right up to her right

Close to her

I said

'I'm going to strangle you in a minute if you don't
go to sleep'

FIONA I didn't know about that?

GRAHAM I didn't tell you.

She started to cry

I felt bad, really bad…

I don't know how nannies do it, do you?

Or childminders

And you Joyce, you have them more than us

FIONA No she doesn't

GRAHAM She does

'Cause most of the time it's just

Well it's so dull isn't it?

JOYCE Yes

FIONA Yes?

JOYCE Sorry?

FIONA *Yes*?

JOYCE What?

FIONA You said yes

JOYCE Yes to what?

FIONA Graham said the kids are dull

GRAHAM No I didn't

 I didn't mean them I meant the daily –

JOYCE Did he?

FIONA Yes and you agreed with him

JOYCE No I didn't

FIONA You did!

JOYCE Did I?

FIONA *Yes.*

JOYCE Oh…

 Beat.

 I better go.

GRAHAM Can't tempt you with a lift?

JOYCE No

GRAHAM Bye then.

 JOYCE makes to leave.

 GRAHAM heads off to the kitchen. FIONA follows JOYCE.

FIONA Mum

 Wait a minute

 Is that OK?

 OK about the

 Money?

JOYCE Oh oh yes

FIONA Thank you

 I'll come over

 Maybe tomorrow and

JOYCE Tomorrow?

FIONA Yes you could give me a cheque or

 I'll phone

JOYCE Phone yes

Bye then

FIONA Bye

JOYCE exits.

GRAHAM reappears. Glass of cold white wine in one hand. Packet of pills in the other.

FIONA I thought she liked coming over here…

GRAHAM She managed to get to the chemist

Holds pills up.

FIONA I don't think you're supposed to drink by the way

If you're planning on taking them

He looks at the dosage on the box.

Are you planning on taking them?

GRAHAM Not all at once…

Beat.

Did you ask for the money?

FIONA I asked for two thousand

GRAHAM Did you?

FIONA You think that's too much?

I think that's too much

GRAHAM No

God no…

Well done.

He drinks.

SCENE SEVEN

An old-fashioned old man's pub in East London. Afternoon. JOYCE is sitting at a small table. She is sipping a glass of wine. Lights are low, very dingy but it's quiet. Music plays in the background. A girl approaches, this is CANDY. She is in her early twenties, she has a pint glass in her hand. There are a few pound coins in the bottom. She hesitates slightly when she sees JOYCE but approaches her anyway.

CANDY Money for the jug?

She rattles the pint glass.

JOYCE What's that?

CANDY Pound for the jug please

She rattles the glass again.

JOYCE Collecting are you?

CANDY Yeah

JOYCE Wait a minute

JOYCE rummages in her bag and picks out her purse from her bag.

I haven't got much change

Will fifty pence do?

CANDY No

It's got to be a pound

That's the minimum

JOYCE The minimum…?

CANDY You can give more if you like

JOYCE I didn't know there was a minimum

In church I usually give 50p

Not that I go to church, but if I take my mother

What's the charity?

CANDY Charity?

JOYCE Yes, who are you collecting for?

CANDY It's for my friend, Mandy

 JOYCE What's wrong with Mandy?

CANDY Nothing

 JOYCE Is she homeless?

CANDY No

 JOYCE You don't look homeless?

CANDY We're not.

She rattles the glass.

Come on love

A pound

It's compulsory

 JOYCE Compulsory?

CANDY Yeah.

 JOYCE Are you one of those…chuggers?

CANDY One of those

 JOYCE You mug people for charity.

JOYCE is rummaging around in her purse trying to come up with a pound.

Does the manager know you're doing this?

CANDY Listen love

Everyone has to put a pound in the jug up front

I collect for Mandy

She collects for me

 JOYCE Who's *Mandy*?

Suddenly music strikes up and (off stage) MANDY performs her strip routine to 'Golddigger' by Kayne West. We don't see this but we do see JOYCE suddenly realise what's going on. JOYCE watches MANDY. CANDY watches JOYCE. Then:

CANDY *That's* Mandy.

I know it's not Stringfellows but she's worth a quid.

*JOYCE puts the money in the jug. Keeps putting money in
frantically.*

JOYCE I was at an exhibition

Round the corner

This pub it

Looked like the sort of place I used to go to when I
was I was a girl

But without the the the…

Beat.

It's not even lunchtime!

They watch.

CANDY She's very good is Mandy

She works at Rhino in the evening

She's quick and precise

Real technician

Not like me

I know my limitations…

Watch her get up that pole

JOYCE Wow!

CANDY Upper-body strength.

Never works for me

I tried it, couple of times

Kept falling off

You need the grip see

You need the thighs.

It's all about coordination

You've got to find your centre.

I don't think I've got a centre

Somebody told me once I might be dyspraxic

JOYCE Dis-what?

CANDY It's a chronic neurological disorder

Pause.

What's your name?

JOYCE Joyce

CANDY I'm Candy

JOYCE Candy and Mandy?

CANDY That's right.

We used to have a Sandy but she left.

Beat.

You've got an empty glass there Joyce

Why don't you have another drink?

You could buy me one too if you like

Mine's a Blue Lagoon.

MANDY off stage whips her knickers off.

I'd look away now if I was you.

JOYCE Why?

She's doing very well

MANDY displays all offstage, JOYCE reacts. MANDY's act finishes.

BAR MAN Candy you're up.

CANDY Go on get us that drink…

Give me something to look forward to.

JOYCE gets up to go to the bar. CANDY exits to do her routine. Her music starts. It's 'Money' by Girls Aloud.

SCENE EIGHT

The same. Fifteen minutes later. JOYCE and CANDY are sitting together sipping their drinks. JOYCE sips wine, CANDY sips her Blue Lagoon. CANDY in a dressing gown post-dance. Jug of coins on the table.

CANDY About two years now

Girl from my area, she did it

Said you could make money

I came down, they took a photo

I had an interview heard nothing.

But then one night they were short of girls and they
rang me

I was told: bring two outfits

Something slinky

Something fancy dress…

So I brought my red spandex and my wings and
tutu for my fairy

When the manager saw me he took one look and said

What the hell have you come as?

I said I'm a fairy you said fancy dress

And he said 'I said *fantasy dress*'

That was my first day

JOYCE You remind me of someone

CANDY Oh everyone says that.

JOYCE Do they?

CANDY Yeah

People who come in here

'You remind me of my secretary or my ex-wife or
my daughter'

I think I've got one of those faces

Sort of…familiar

Who is it I remind you of?

JOYCE A friend

Girl I used to work with

This was a long time ago

CANDY Oh yeah

Was she pretty this friend of yours?

JOYCE Yes.

Much prettier than me

Her name was Doreen.

I met her in Woolworths.

We used to work there together on a Saturday

It was my first proper job.

CANDY There used to be a Woolworths on the high street

Everyone goes on about how much they miss it but

I don't, it wasn't very good was it?

JOYCE I used to stack shelves

My friend, she was on the till

It's an important job being on the till.

Not like now

Now they just beep the label through

But then...it used to get really busy

Especially on Saturdays or the run-up to Christmas.

But we had fun

We'd laugh at the customers

Give them nicknames

The regular ones

CANDY Yeah, we do that here

They both drink.

JOYCE We had this supervisor

Mrs Kibble

She was terribly mean.

CANDY Sounds mean, name like that

JOYCE I was terrified of her but not Doreen...

She was very confident

Not like me

She had quite a few boyfriends

A bit like you I expect

Pause.

Except…one day, Doreen turned up at work

She'd managed to get two tickets to go and see the Beatles

CANDY The Beatles?

JOYCE Yes.

They were playing the Guildford Odeon

She wanted me to go with her

Only thing was, in order to go, we needed to sneak out of work early

And there was no way Mrs Kibble was going to let us

But I was desperate to go

I was in love with Paul McCartney

CANDY I always felt sorry for him

You know all that business with Heather Mills

She took advantage

I mean, he's an old man, isn't he?

JOYCE I'm the same age as Paul McCartney.

CANDY Are you?

Oh sorry…I didn't mean

JOYCE It's alright

CANDY Must have been amazing though, eh?

Seeing the Beatles

When they could sing

JOYCE I didn't go

CANDY What?

JOYCE I never went

CANDY But you had the tickets

JOYCE When the day came

I couldn't do it.

I told Doreen I would cover for her but I wouldn't risk it myself.

I was scared of Mrs Kibble finding out

Which is ridiculous because I hated Mrs Kibble.

But what if she'd phoned my mother…

Pause.

Doreen went of course

CANDY Least one of you did

JOYCE Spent the entire evening on the front row

Afterwards she got invited back stage, met the
boys.

She ended up spending the night with Paul
McCartney in the Dorchester hotel.

Apparently he was a wonderful lover.

Pause.

After that, I decided never to listen to my mother
again…

She drinks.

Pause.

CANDY Bet she lied, your friend

She made that story up.

Bet she never met Paul McCartney

Pause.

JOYCE You know, all these years…I'd never considered that.

What do you see when you look at me?

What 'sort of woman' am I?

CANDY What?

JOYCE Do I look respectable?

CANDY Suppose?

JOYCE Suburban?

Or just…old

Am I an old woman?

CANDY Why don't we have another drink?

This time

I'm buying

Have a Blue Lagoon

SCENE NINE

Same night. PEARL's flat, middle of the night.

FIONA And you thought you heard a bang?

PEARL A bang.

Yes

FIONA What like a car going off?

PEARL No

Bang like a gun

FIONA You thought you heard a shot?

PEARL Yes that's right a shot

Bang bang

I didn't want to get you up dear

All the way over here, pregnant

Not in the middle of the night

But who else could I turn to?

I tried your mother

She's not answering the phone

FIONA She's probably asleep

PEARL Or out

FIONA I doubt it Gran

It's four in the morning.

PEARL Well she didn't come and see me this evening

FIONA 'Course she did

You've forgotten that's all

PEARL No, I'm telling you

And she didn't even have the courtesy to let me
know

FIONA But she always comes

She watches the soaps, you read the *Mirror*

PEARL The *Mail*

FIONA Sorry

Did you try her mobile?

PEARL Of course

No answer

FIONA But it rang?

PEARL Yes

FIONA Well…maybe she didn't hear it

Look, if you're alright I better go

I've got work tomorrow

Let's get you back to bed

FIONA starts to lead PEARL away.

PEARL It's ever so messy in here

What's Frank gonna say?

FIONA Not much he's been dead for twenty years

PEARL I am ashamed you coming here seeing the place
like this

FIONA You need to throw things out Gran

You've not got the room here for –

Get Mum to clear some of the junk

PEARL I'd do it myself but

Well it's the papers

They build up dear

Supplements, free things

FIONA Well tell Mum to put them out

She's good at clearing up

She'll look after you

Ask her to hoover

PEARL I've got a hoover not sure it works

Do you want to have a look?

FIONA No not right now

We'll

Do it another time.

Come on

PEARL I'm ever so worried

FIONA Don't be

PEARL Worried about Joyce.

Beat.

She goes to coffee houses

Dresses up

Black stockings lacquer in her hair

She smokes cigarettes

Joseph Kelly, from across the road, he saw her.

He came round to see me last week

Your girl your Joyce

You want to keep her in Pearl

Keep her indoors

FIONA Granny?

PEARL She used to be such a good girl did Joyce

Is it the television do you think?

Or music?

Books?

Honestly Frank, we need to do something

FIONA Granny, I'm not Frank

Frank's

He's dead

PEARL What's that?

FIONA Frank

Your husband

He's dead

PEARL Dead?

But he drove me to church this morning

FIONA Come on let's

Let's get you back into bed

You need to sleep.

Do you want me to stay?

I could stay the night if you like if you think it
 might help?

PEARL Oh no

No dear it's –

You are good dear

Coming all this way

A good girl

FIONA Come on

She takes PEARL's arm, leads her off but PEARL stops.

PEARL Wait.

Lock the door will you?

We don't want Joyce getting out.

SCENE TEN

*A week later. Early evening. FIONA's flat. GRAHAM has
a mobile phone. He is frantically trying to call someone.*

GRAHAM Come on come on come on

Phone goes to voicemail.

Shit!

Voicemail message finishes.

Yeah yeah

It's me

Again

I've been to the school

They said…

Just call me when you get this yeah

He hangs up and we hear a door off. Children's voices. Then FIONA off.

FIONA *(Off.)* In the kitchen.

WILLIAM *(Off.)* Where in the kitchen?

MOLLY *(Off.)* Take my coat off

FIONA *(Off.)* Yes yes alright

WILLIAM *(Off.)* Did you get me a snack?

FIONA *(Off.)* What snack?

WILLIAM You forgot my snack!

I wanted crisps

FIONA *(Off.)* Well you can't have crisps

Molly pick that coat up!

WILLIAM *(Off.)* Oh Mum

FIONA *(Off.)* Molly come here now

Molly!

MOLLY *(Off.)* Bye!

FIONA *(Off.)* DONT JUST DUMP IT!

Oh for God's sake!

FIONA enters with her coat on. Children's school bags in hand.

FIONA You're here

GRAHAM I'm sorry

FIONA What happened?

GRAHAM I forgot

I'm

I can't keep up

Tuesdays and Thursdays doesn't Joyce pick them
up?

FIONA She picks them up Tuesdays, Wednesdays and
 Fridays

GRAHAM So don't they go to the after school club anymore?

FIONA No!

 We changed that remember?

 Because after school club costs money and we
 don't have any money

 This term, we said we wouldn't do after school club
 because you could pick them up on Thursday.

 They called me at work Graham

 Where were you?

 I had to leave early

GRAHAM Couldn't one of the other mothers have taken them?

 Joanne?

FIONA It's *one* thing

 One thing I ask you to do

GRAHAM Jesus!

 All this it's

 I can't do it anymore!

FIONA *You* can't do it?

 Look at me Graham

 I'm drowning.

 She sits down.

 God I wish I'd married someone with ambition

GRAHAM What the hell does that mean?

 I have ambition!

FIONA No Graham you have dreams

 When I first met you

 You had nothing

 No flat, no savings nothing

 You were so poor you were a vegetarian

 If I'd married someone with a bit of ambition
 someone with a proper career

 We'd have a big place by now

GRAHAM You've really thought about this haven't you?

 FIONA Look at Joanne

GRAHAM Oh here we go Joanne

 FIONA Huge house backs onto the common

 Three floors, double fronted

 A holiday home in Devon

 She and her husband own a FOREST!

GRAHAM I thought you hated Joanne's husband

 FIONA I do!

GRAHAM So what are you going on about?!

 FIONA I'm exactly the same age as Joanne

 I am having our third child and all we have is is this.

 This…shitty maisonette that even my grandmother
 thinks is a dump

 The place I bought years ago which we still haven't
 paid off

 Which any day now we might lose and why?

 Because you decided to quit yet another fucking
 job

GRAHAM It was a terrible job

 FIONA No Graham it wasn't a terrible job

 Teaching guitar, three days a week to nice boys in a
 prep school

 Is not a terrible job

GRAHAM It wasn't what I wanted to do!

 Those bloody kids

 FIONA Were what?

 Well behaved?

Polite?

GRAHAM No they...scared me

FIONA Ten-year-old boys called Tarquin *scared* you?

GRAHAM They were so *young*

Had their whole lives ahead of them

Made me feel like...time was running out

FIONA Time *is* running out Graham.

We can't survive on one income

We have no savings

We won't be able to pay the mortgage

I can't keep borrowing from Mum

GRAHAM And why do we have no savings?

FIONA Because you quit another job!

Hello?

Are you following this conversation?

GRAHAM No hang on a minute

We've no savings because everything you earn you spend.

FIONA I do not.

GRAHAM Every season you buy another Mulberry bag.

FIONA Hey hey hey no, I *work* I *earn*, that's my treat

GRAHAM And the regular shoe purchases they're a treat too are they?

And the chemical blow drys, lowlights on your hair once a month?

FIONA Once a month?

It's not once a month

GRAHAM You LIVE IN THE HAIRDRESSER'S

FIONA I need to look smart for work

OK?

It's all right for you you're a musician,

Unemployed musician

It doesn't matter what you look like

GRAHAM You're an office manager in a call centre

Your entire staff is made up of Aussies and South Africans on student visas

The dress code isn't 'sex in the city'

You do not work for *Vogue.*

FIONA It isn't me

Who has pissed around playing the guitar for the best part of twenty years

pretending to be a pop star!

GRAHAM *Pop star!*

Is that what you think?

We were in the *NME* Fiona

We played the Reading Festival

FIONA On a wet Friday morning in 1995

GRAHAM I do not write pop songs

FIONA No you're right you don't

If you wrote pop songs you might earn some money

Instead you write about wizards and goblins

GRAHAM I hope you are not referring to the Tolkein EP

FIONA Yes Graham I am referring to the Tolkien EP

GRAHAM 'Homage to the Hobbit' is *not* about Goblins!

Exits. Returns with coat.

I'm off

FIONA *What?*

GRAHAM I need some space!

Time on my own to think

FIONA Oh you're leaving me again?

GRAHAM No I'm not fucking leaving you I'm

FIONA Well fuck off then

GRAHAM Listen to me

FIONA FUCK OFF!

GRAHAM Just LISTEN TO ME YEAH

I need to THINK

Just for a week a month a

FIONA A *month*?!

GRAHAM YES

FIONA It's time to grow up Graham?

This is not the time to go AWOL again

GRAHAM I'll go to my brother's, Andy's

If you need me that's where I'll be

FIONA What now?

GRAHAM Yes now

SCENE ELEVEN

JOYCE's house. Morning. A week later.

PEARL Two buses

JOYCE It's not two buses

PEARL Then I must have got the wrong one

Should have got the train

You know where you are with the train

I'm exhausted.

They ought to do something about that hill

JOYCE What if I hadn't been in?

You should have phoned

PEARL It's Wednesday

JOYCE So?

PEARL So, this is the day we visit Tony.

JOYCE Oh Mother not the graveyard

PEARL Didn't go last week did we

You didn't turn up

I thought if I come here you can't get out of it

I need to sit down

Fetch me a cup of tea

JOYCE You don't need to do this

Why did you do this?

PEARL If I didn't come up here I wouldn't see you

JOYCE You'll be *seeing* me tonight

I'm coming tonight

I did tell you

PEARL No you didn't

JOYCE *I did*

You forget

You say you don't but

PEARL I can't keep up

Ever since Tony died you've been messing me about

I don't know where I am with it all

Why can't we keep it the way it was?

JOYCE Because I didn't like it the way it was

PEARL What am I supposed to do all evening all on my own?

I'm an old woman I need company.

Conversation.

Daily interaction.

JOYCE So see your friends

PEARL Friends?

What friends?

All my friends are dead.

Wish I was dead.

If I was dead I'd be happy.

You'd be happy

If I was dead you wouldn't have to worry.

JOYCE What about Mary Lomax?

She'll come, she'll visit

PEARL Mary Lomax!

Jesus I'm not that desperate

JOYCE You could ring David

PEARL David?

JOYCE Yes

Your son.

Remember him?

Get him to come over

PEARL They're miles away

JOYCE They live in Epsom!

PEARL He's got better things to do

JOYCE So have I!

PEARL That's *different*

JOYCE Oh of course it is.

PEARL Where are you going Joyce?

Where are you going at night?

JOYCE sits down.

Pause.

JOYCE To a pub

PEARL A pub

What pub?

JOYCE In town

London

PEARL London?

JOYCE Yes

I've made some friends there

New friends

PEARL Men?

JOYCE No.

No.

Women

They're…dancers

PEARL Dancers?

JOYCE *Yes*

PEARL What like…

Not…showgirls, Joyce

JOYCE No

PEARL Well thank God for that

JOYCE They're strippers

PEARL What?!

JOYCE Strippers

You know

They take their clothes off for money

PEARL I know what a stripper is!

JOYCE I went by accident I didn't…

One afternoon

PEARL Jesus Mary and Joseph

JOYCE They *like* me Mother.

They treat me like a queen

I sit in the corner, they bring me drinks we talk.

PEARL Dear God!

When I think of all the effort me and your father
put in

Making you respectable and this is how you repay
me?

Mixing with a bunch of strippers!

We set you up!

JOYCE Oh yeah, you set me up all right.

Here you go Joyce, marry Vera Ponsonby's boy, he's still at home

Boy?

He was nearly forty!

He'd been on the shelf so long Vera had to dust him down.

PEARL That man was a catch

Catch for the likes of you.

That family had money

Old money

You wouldn't be in this house now if it wasn't for them.

The way you were carrying on you'd have ended up with no one

You were wild Joyce

JOYCE I wasn't.

I know you thought I was.

But really…I wasn't

Not compared to nowadays

PEARL Well no

Not compared to now, no 'cause nowadays it's gone mad

All these girls, women

Nights away from their husbands

Hen parties, knees-up

Working spending

JOYCE I should never have listened to you.

I knew who I wanted.

PEARL We *all* knew who you wanted.

Except he wasn't yours to have, was he?

I will NOT have people coming 'round here

You hear me?

Screaming at my front door

Do you understand?

Respectable, that's what we are

WE ARE RESPECTABLE PEOPLE!

PEARL seems confused for a moment. Doesn't know where she is.

JOYCE I'll fix you that cup of tea.

SCENE TWELVE

Midnight, outside the White Horse. JOYCE is just leaving. Goes to a taxi rank. A man steps out of the shadows, approaches.

MAN Looking for a cab?

JOYCE What?

MAN Mini cab?

Where you going love?

I can take you

JOYCE No thank you

MAN Where do you live?

JOYCE Sorry?

MAN Where you live?

JOYCE Miles away

Excuse me

MAN I wouldn't bother with the rank love

Not this one

They don't bother to come here

JOYCE They do

You just

Have to be patient

MAN But I'm cheaper

Loads cheaper

Wherever you want to go

I can take you

Where do you want to go?

Beat.

JOYCE Cheam?

MAN Twenty quid

That's all, twenty

Come on

JOYCE I don't

MAN I'm alright, it's safe

I take all the girls here

You ask them

They know me in there

You talk to Candy

You know Candy?

JOYCE Yes

MAN Well, you talk to her

She'll tell you I'm kosher

Beat.

You working in there?

JOYCE No

MAN You could

You're a bit older than the usual

JOYCE Well thank you

MAN No really

You got a good pair of legs

Could glam up a bit but then it's only the White
Horse

But your face ain't bad

You got good bone structure

Knew a woman once

Friend of my mother's

She said, you'd be alright if you had good bones

Good bones and nice hands

She had nice hands…

Have you got nice hands?

JOYCE I've never really thought about it.

She looks at her hands… He gets out cigarettes.

MAN You smoke?

JOYCE No.

*He lights up. Takes a long drag. JOYCE finds herself enjoying
the smell of the smoke in the cold night air. MAN notices this.*

MAN Want one?

Pause.

JOYCE nods. Goes over to the man. He lights her a fag.

MAN Given up had ya?

Hard innit when you've given up

Someone lights up it's very tempting.

That fantastic smell

Don't know why people complain about it

Smell of a fag in the cold air will always remind me
of a good night out.

When I was a lad, long as I'd got a drink in one
hand, fag in the other

Arm round a bird I was happy.

Your old man know you're out?

JOYCE He's dead

What about your wife?

MAN Sadly she's still with us

She got married again last week, to her cousin

They'd been having an affair for years…

Pause.

JOYCE smokes.

JOYCE I had an affair.

Once

It was with my next-door neighbour

He was going to leave his wife.

MAN Your husband know?

JOYCE No this was

Years ago…

When I was a girl.

He was older than me, bit older

Not handsome but

Made me feel…

MAN Wanted

Pause.

JOYCE Those the best three months of my life…being with him

Pause.

MAN Let me see your hands

JOYCE My

MAN Hands

Here

MAN takes JOYCE's hands, gently.

See, I was right

You got lovely hands

Lovely long fingers

Tiny wrists

Lovely.

Pause.

Why don't we go round the corner?

JOYCE Corner?

MAN There's an alley, up the back

Bet you'd love that

Back against the brick…

He starts to move.

Still has her wrist.

JOYCE No

MAN What?

You won't find what you want watching a bunch 'o strippers

Beat.

I won't hurt ya

Ask Candy

JOYCE Candy?

MAN Yeah…'course

I'm not like her other punters…

Beat.

I give and take

JOYCE You're old enough to be her *father*!

MAN I'm old enough to be her *grandfather*

JOYCE pulls away.

JOYCE You disgust me

MAN Good

That's always worked in my favour.

MAN grabs her hand.

JOYCE No!

MAN Come on

She pulls clear.

JOYCE No!

You shouldn't be allowed on the street!

You

You're a

You're a disgrace!

MAN Yeah yeah alright alright calm down

JOYCE I am a respectable woman!

You show some respect!

MAN Respectable women don't hang around strip bars at
one in the morning

You come here

You want something

JOYCE Well it's not you.

MAN So fuck off then.

Go on

Fuck off

JOYCE starts to exit quickly.

MAN Stupid bitch…

Pause.

He looks in the direction of where JOYCE exited.

Then walks quickly in the same direction following her.

SCENE THIRTEEN

*FIONA and GRAHAM's flat. FIONA is sitting in a chair, eyes
closed. Asleep. GRAHAM enters.*

GRAHAM Fi?

FIONA wakes up startled.

FIONA Shit!

	God
	You
GRAHAM	Sorry
	Sorry
	You OK?
FIONA	Yeah I'm…

God

You

GRAHAM Sorry

Sorry

You OK?

FIONA Yeah I'm…

Fell asleep.

Pause.

Thanks for coming

GRAHAM How is she?

FIONA She's alive

GRAHAM Thank God for that

FIONA But it doesn't look good

GRAHAM They let you see her?

FIONA No

They told me to come home

No point in staying

Wait for a call

The doctor's going to ring me

GRAHAM Oh babes…

He kneels down, takes her hand.

Do they know what happened?

FIONA A fall.

Slipped on the old blue carpet

She must have been there for hours

Lying there

GRAHAM Poor Pearl…

FIONA And I can't find Mum anywhere

I've left messages

I keep ringing the house, she's not there

GRAHAM It's one o'clock in the morning she'll be asleep

FIONA Oh this is rotten timing

As if I haven't got enough to worry about

Now it's Granny

She could be in hospital for months Graham

Joanne's gran

She had a stoke

She was visiting her in St George's for a year.

GRAHAM That's Joanne's gran

Not as tough as Pearl.

No one's as tough as Pearl.

FIONA And what happens when she comes out?

GRAHAM Let's not jump ahead of ourselves

FIONA She won't be able to go back to her flat.

We'll have to clear it

She's lived there her whole married life never
 thrown anything out

It's full of crap

Years of junk

We'll have to take down the net curtains

Dismantle the bed

Dispose of her unused medication.

I'll have to go through her underwear find her teeth

I'll spend hours just driving up and down the Ewell
 bypass!

GRAHAM This is Joyce's problem not yours

She's Joyce's mum

FIONA I had this funny conversation with Granny a
 couple of weeks ago

She swore Mum hadn't been to see her

She'd been trying to call her

All night she tried

I thought it was Granny just getting confused but now…

Well where is she?

GRAHAM Maybe she's having a night out.

FIONA This is my mother we're talking about

GRAHAM Maybe she's doing her own thing

FIONA What own thing?

GRAHAM I don't know

Boyfriend?

FIONA My mother?

Now you're being annoying.

GRAHAM Look, I know I haven't been here

FIONA No. You haven't

GRAHAM And I'm sorry

I'm really sorry.

But the last month it was

Everything's been so stressful

FIONA Graham

GRAHAM Wait a minute.

I've had a chance to think and

I'm gonna quit the music

I'll teach full-time

I'll teach in fucking Norbury

I'm gonna focus on you and the baby and the kids

Beat.

I'm gonna come back home.

Pause.

FIONA We had the bailiffs round last Tuesday

I hid behind the telly

Pause.

And the bank's foreclosed

We've got a month to get out.

SCENE FOURTEEN

Afternoon. A week later, the Ritz Hotel. JOYCE and CANDY are having afternoon tea. A piano tinkles in the background. CANDY is taking photographs of the food with her mobile.

CANDY I've never seen so much cake in all my life

I've never eaten so many sandwiches

JOYCE You have to pace yourself

Eat too many sandwiches and you won't have room for cake

CANDY But I love these sandwiches…

They cut them up nice don't they?

JOYCE Well it is the Ritz

Would you like some more champagne?

CANDY I wouldn't mind

JOYCE calls a waiter over. CANDY photographs him, he pours the champagne.

WAITER Madam

CANDY Ta

CANDY looks at her photo.

This is really good of you Joyce

Dead nice

You sure you don't want me to pay half

JOYCE No no

I wanted to come here for my sixtieth birthday

I had this idea that I'd come into London

Have tea at the Ritz

Only…I never actually told anyone that's what I
wanted

So we went to an Italian in Tadworth

CANDY Aw

Hey, why don't we pretend it's your birthday
today?

We could celebrate now

JOYCE But it's not my birthday today

CANDY It don't matter

She shouts to the waiter.

Excuse me?

WAITER Madam?

CANDY Can you have a word with the piano man

See if he knows Happy Birthday?

He goes off.

JOYCE Candy I don't

CANDY Here

*She puts the glass of champagne in JOYCE's hand, cake in
the other.*

Look at the camera

Smile Joyce.

There

Now you're ready for Facebook …

The pianist strikes up a chord then goes into Happy Birthday.

CANDY sings to JOYCE.

*JOYCE is a little embarrassed. Not because of CANDY but
for herself.*

Happy birthday to you

Happy birthday to you

She can't help herself going into a little dance just round her chair, it's slightly lewd, and not very good with flicking of hair, etc.

Happy birthday dear Joycey

Happy birthday to you.

She swings her hair around and then sits down.

Pause.

JOYCE Have a strawberry tart

The pianist strikes up 'Moon River'.

CANDY takes the tart, tucks in.

CANDY Is your mother still in the hospital?

JOYCE Yes

CANDY How is she?

JOYCE I don't know

CANDY You've not been to see her?

JOYCE No.

CANDY Why?

Do you not like hospitals?

JOYCE What are you doing next week?

CANDY What I always do

Work

JOYCE Take some time off?

We could…get tickets to a West End show.

We could see whatever you like

We could see the show about the horse or the one about the lion

CANDY Joyce

JOYCE Or what about a spa?

You'd like that

We could spend all day wrapped up in fluffy towels.

CANDY Joyce no

JOYCE Have our nails done

CANDY Joyce

This is really nice of you and all that but

JOYCE What?

CANDY I can't do all those things with you

JOYCE Why not?

CANDY Because…this is *your* dream

And I can't be part of your dream…

I've got work

I've got Jason…

CANDY starts to get her things together. Puts her phone in her bag.

JOYCE Who's Jason?

CANDY My kid

JOYCE You have a child.

How old is he?

CANDY Three

JOYCE I didn't know you had a child

Where is he now?

CANDY Woman lives above me, she takes him

I give her a tenner she watches him when I go out to work

I don't think she does much with him right enough but

He's alright, only a baby

Why don't you come round to mine next week?

I'll cook you my chilli con carne

You could meet Jason

I won't be upset if you say no

Beat.

JOYCE You're my only friend Candy

I want you to know that

Beat.

CANDY If you don't mind Joyce

I think I'd like you to call me Jane.

That's my real name.

SCENE FIFTEEN

FIONA's house, next day, early evening. Sound of children off stage jumping about, laughing.

WILLIAM *(Off.)* Jump and hit, jump and hit

Monkey monkey monkey!

MOLLY *(Off.)* Go mental!

FIONA So next week is half-term, right?

Which is a pain, 'cause I sort of

I

Didn't realise

It was on the calendar but somehow

What with everything that's going on I seemed to have

Well I missed it.

It must be early this year or something or

Anyway

It's half-term OK

And I've got to work, 'cause I didn't put in for the time off

JOYCE So you want me to have them every day?

FIONA No.

No of course not, I wouldn't ask you to do that

But I thought perhaps

If you had them on the usual days but

JOYCE That would be all day though, would it?

 Not just after school

FIONA Yes

 But the other two days Graham can have them

JOYCE So Graham's back now is he?

FIONA Yes

 That was just

 Yes, anyway

WILLIAM *(Off.)* Fire at it

 Fire

FIONA So you're OK with that?

WILLIAM *(Off.)* Fire!

JOYCE With *what*?

FIONA *Half-term*

 Those three days?

 You're fine with those days?

WILLIAM *(Off.)* Do it properly Molly

 You're not doing it properly!

JOYCE What are those children doing?

FIONA What?

MOLLY *(Off.)* It's mine it's mine

JOYCE The children, screaming

MOLLY *(Off.)* Give it to me

WILLAM *(Off.)* No!

MOLLY *(Off.)* Give it to ME!

FIONA It's a new

 Video game

JOYCE A video game?

FIONA Yes

WILLIAM *(Off.)* Get off get off!

JOYCE It sounds like they're leaping about

MOLLY *(Off.)* Shoot!

Shoot

FIONA It's Storm Opps

JOYCE What?

FIONA Desert Storm

WILLIAM *(Off.)* Give it me give me now

MOLLY *(Off.)* NO!

FIONA You move and shoot

JOYCE Shoot?

FIONA Yeah with

Pistols and

Army

Anyway…

There's one other thing I wanted to talk to you
about

Ask you about

If I could

WILLIAM *(Off.)* Shoot shoot now shoot

Molly

Dead…

MOLLY *(Off.)* Not fair

WILLIAM *(Off.)* You die!

JOYCE Not Mother

Please I don't want to talk about Mother

FIONA No

I wasn't even going to mention her

MOLLY *(Off.)* You die die!

JOYCE Because we agreed

If there's any change then you would tell me

FIONA Yes

That's what we agreed

WILLIAM *(Off.)* Death to you

FIONA I still think that's a bit odd but

JOYCE That's what we *agreed.*

FIONA Yes that's what we agreed.

WILLIAM *(Off.)* Blast it!!!!!!!!

MOLLY *(Off. Screams.)*

JOYCE Good grief Fiona that racket!

FIONA Look you know we've been having trouble with money

WILLIAM *(Off.)* Mental

Mental

Go mental!

JOYCE What?

FIONA *Money*!

WILLIAM *(Off.)* Mental!

FIONA Since Graham quit his job

JOYCE I think those children are getting worse you know

FIONA Mum I just need to, listen to me OK

MOLLY *(Off.)* Get off William it's mine

Mine!

JOYCE I don't know how you put up with it.

They're spoilt that's what they are

MOLLY *(Off.)* Mummy!

Screams.

JOYCE I mean why can't they just SHUT THE FUCK UP!

Beat.

FIONA What?

JOYCE The children.

Maybe they should shut the fuck up.

Beat.

FIONA Are you alright?

JOYCE I'm fine.

Perfectly fine

JOYCE I'm not doing half-term

FIONA What?

JOYCE Half-term

I'm sorry but

I think

From now on

I don't want to pick the kids up anymore

I don't want to.

FIONA Oh, OK…

JOYCE I don't mind them coming over to me or

But all day

I'm running out of…

No more.

Alright.

I can't do this anymore

FIONA OK

Well, we'll sort something else out

If that's what you want

JOYCE Yes

That's what I want.

Pause.

FIONA We have to move out by the end of the month

The bank are repossessing

JOYCE How on earth did that happen?

FIONA Oh does it *matter*?!

We could try and find somewhere to rent but

We don't have the money for a deposit

JOYCE You want more money?

FIONA No.

Look…

I've been thinking…

Sometimes…when I need to solve a problem I

I think…what would Dad do?

He was always so careful

So methodical wasn't he?

Did things the proper way

Never made mistakes

JOYCE No

FIONA And I was thinking…

I thought…what would Dad say if he was here?

What would he tell me to do?

And I think…

I think he'd tell me to come home.

JOYCE Home?

FIONA Yes

Back to my family home

The place I grew up

The place I feel safe

Beat.

We need to move in with you Mum.

I need to come home.

Beat.

JOYCE You want to move into *my* house?

FIONA Yes.

JOYCE All of you?

FIONA Well yes

JOYCE But

FIONA What?

JOYCE Well…

Pause.

What about Granny's?

FIONA *Granny's?*

JOYCE Yes.

She's in hospital there's no one there you could
stay there

FIONA But

No.

Mum

That's…

Don't be ridiculous.

JOYCE Why is that ridiculous?

The place is empty

FIONA But Granny's flat it's…

I mean come on!

It's too small for a start

JOYCE This place isn't much bigger

FIONA But it's…

Well it's not suitable is it?

Not for us

JOYCE There's nothing wrong with it

FIONA I'm not saying there's anything wrong with it

But you've got all that space at your house

JOYCE Oh Fiona

FIONA Look, *please*

Just till we get back on our feet.

We're desperate Mum

I need your help.

I need you to say yes

Pause.

Please say yes…

SCENE SIXTEEN

FIONA's house, that evening.

GRAHAM But what did she actually say?

FIONA She said that was fine and then she hugged me

GRAHAM So…you didn't put a time limit on it or

FIONA No

GRAHAM You didn't say, it's only for the short term or

You never sold it to her like that?

FIONA I didn't have to 'sell it' Graham

This is what families do

They help each other

Anyway, it's my house

GRAHAM No it's not

FIONA It will be

One day

Eventually

GRAHAM Yeah, eventually

When she dies

FIONA Yes.

When she dies but

I said look, it's my family home

This is what Dad would have wanted

GRAHAM And she said…?

FIONA She said fine, alright come home and then she
 hugged me and that was that.

 Why are you asking me all these questions?

GRAHAM I just want to make sure you've got it right, that's all

 I know what you're like

FIONA What am I *like*?

GRAHAM You hear what you want to hear

 You set things up and then…you're off

FIONA I get things done, if that's what you mean

 Beat.

 Anyway, she could do with the company

 It can't be much fun being on your own in that big
 house

 Rattling around

 No wonder she's out all the time

 She's probably lonely.

 And the house needs work

 They haven't touched it since the Seventies

 We could do a few things

 Sort things out

GRAHAM You mean DIY?

FIONA Yes or

 Well you could make yourself useful

 I thought last time I was round there that she could
 do with a new bathroom.

GRAHAM Really?

FIONA Yes

GRAHAM I think she needs a new kitchen.

FIONA Kitchen?

GRAHAM Yeah those units

 They're quite dated

> But who's going to pay for it?

FIONA She will initially, I suppose

But either way it's an investment isn't it

That house one way or another

It'll be ours eventually

If we help Mum do her place up and then…well ultimately we benefit too don't we?

Beat.

GRAHAM Yeah…

SCENE SEVENTEEN

JOYCE's house. A week later. Afternoon. She has a large trunk. CANDY and JOYCE stare at it.

CANDY A clear-out.

JOYCE That's right

I need to make space

My daughter's coming to stay for a bit thought I'd get rid of a few things

CANDY What's in it?

JOYCE Wait and see

JOYCE opens the trunk, pulls out a beautiful dress.

CANDY Wow!

JOYCE I must have bought this oh…forty years ago

CANDY Where did you get it?

JOYCE I don't know

Some boutique in Guildford

Closed down now

Do you like it?

CANDY Yeah!

JOYCE I've never worn it

CANDY You must have

JOYCE No

I've barely worn any of the things in here

Look

She pulls out another dress, even more beautiful, evening gown.

CANDY Fucking hell

You must have worn that.

JOYCE No

I just kept them in here, all this time

You want to try them on

Go on

CANDY Nah.

Looks too delicate

JOYCE Don't be ridiculous

Try it.

CANDY Alright

CANDY, excited to try the dress, takes her clothes off. The expert in the quick change.

JOYCE Keep your knickers on

JOYCE is rummaging through the box.

Pulls out a Bianca Jagger-style hat.

JOYCE God I remember buying this…

I remember

Fiona was in the pram

She was crying

She never liked shopping when she was little.

Not like now…

She puts the hat on.

You're supposed to wear it to the side

She plonks it on her head.

CANDY Suits you

JOYCE No it doesn't.

She takes it off.

CANDY Can you zip me up?

JOYCE Come here

JOYCE zips CANDY into the dress.

Breathe in

CANDY I am I am.

She turns round.

JOYCE There.

You look lovely

She does. It's JOYCE's dress so it's a bit long on her but this makes it look even more ball gown-like.

CANDY Nobody wears stuff like this anymore

I think people would be a lot nicer if they did

You can't get pissed and shout 'Fuck off' wearing this get-up can you?

CANDY looks down at the dress she's wearing and feels the material against her body.

JOYCE I want you to have it.

CANDY What?

JOYCE That dress

Take it home

CANDY I can't

JOYCE You can

Use it in your act

CANDY I'd never get it off.

I need easy access

They laugh. JOYCE rummages in the trunk again.

JOYCE Now, I knew this was in here…

JOYCE pulls out a huge white dress, it's her wedding dress. It's extraordinarily beautiful.

CANDY Fucking hell Joycey!

Fucking hell!

JOYCE It's my

CANDY It's your wedding dress!

JOYCE Yes

CANDY That's

It's like a dress for The Queen!

JOYCE I wore this

CANDY Well…YEAH!

I'd hope so

JOYCE Only once mind but

I wore it

CANDY Must have looked…amazing

JOYCE Maybe

I don't know

I don't remember…

Tony chose it, my husband

CANDY Your husband chose it?

Isn't that a bit…

JOYCE Unusual…yes…

Tony was…unusual

Beat.

CANDY How long were you married?

JOYCE Forty-five years

Pause.

CANDY Bloody hell Joyce…

Well he had good taste…

JOYCE Do you think we could sell it?

Ebay or something

CANDY You wouldn't want to sell that

JOYCE Why not?

CANDY It's your wedding dress!

JOYCE I don't want it

CANDY Don't be silly

JOYCE You take it, sell it

Vintage fashion I bet you'd make a fortune

Beat.

CANDY Joyce

This is

You giving me money again innit?

JOYCE I never even mentioned money

CANDY Ever since you came round to my place

You've been trying to give me money

JOYCE Nonsense!

CANDY But

Your daughter, won't she want it?

JOYCE She doesn't know I've got any of this stuff

CANDY You've never shown her the dresses?

JOYCE No

Why would I?

Beat.

Take them

Sell them split them up

Keep them I don't care

It's a gift

CANDY Alright I'll take the dresses

But I'm not selling them.

If you give them to me I keep 'em.

JOYCE Let's stuff them all back in here

Shove the trunk in a cab

You can take them home

JOYCE goes back into the trunk, suddenly she stops. She's found something at the bottom.

JOYCE Oh…

I haven't seen this since

CANDY What is it?

She gets the record out. Turns the record over in her hands.

JOYCE A single

45.

You've probably never even seen one of these have you?

CANDY Does it work?

Beat.

JOYCE I expect so…

Hang on

JOYCE goes off. She keeps talking even though she's out of the room.

I was going to throw this out.

Don't think charity would take it

No call for these nowadays what with

CDs and downloads and

JOYCE re-enters with a case.

Found it this morning.

CANDY What is it?

JOYCE It was Tony's

He used to get Henry Mancini cheap on Sutton High Street.

Let's see if it works.

JOYCE plugs the player in. Opens it up, the turntable spins round, CANDY hands her the record.

JOYCE makes sure she's got the right side.

We want the A side not B.

It might be a bit crackly

I used to play it a lot…

Me and Doreen we used to go to her house

Play it in her attic bedroom.

Here we go.

A moment while she puts it on the turntable. Lifts the arm, etc. A crackle and then…it plays. The sound of 'She Loves You' by the Beatles shoots loudly into the room. They both stand for a moment listening. Then JOYCE bobs about. Then she starts to move. She looks to CANDY who moves too. At the moment when the Beatles first sing 'whooo' they join in and start to dance. JOYCE dances very well, twisting, etc. She grabs CANDY's hand and twists her round to the music; she almost goes flying. They shout over the music.

JOYCE I'm sorry Jane but

You are the WORST dancer I've ever seen

CANDY I know!

JOYCE Which, considering you're a stripper...

CANDY Is really fucking bad news!

They continue to dance. CANDY very badly.

JOYCE You have to find something else

CANDY What?

JOYCE Find something else!

To do

CANDY Like what?!

Not like I've got a CV is it?

WHOOOOOOO!

CANDY spins round. Keeps dancing very badly. The music continues to play. JOYCE stops. Stares at her. Suddenly a phone rings. It's JOYCE's mobile; it's under some of the clothes. She fetches it, just in time. CANDY takes the record off.

JOYCE Hello?

Hello yes?

Yes?

What?

Pause

No I didn't.

I see…

No well…if you're in the area…

Bye.

JOYCE hangs up.

CANDY You alright?

JOYCE That was a builder

Apparently I've asked for a quote…

SCENE EIGHTEEN

FIONA's flat.

JOYCE What did you think you were doing?

Renovations on my house

You haven't even moved in!

FIONA Calm down

JOYCE I thought this was just a just a

Temporary measure you coming to live with me

FIONA A temporary measure?

JOYCE Till you got yourselves back on your feet

That's what you said

FIONA I know that's what I said

But I don't know how long that's gonna take.

JOYCE Can you can you give me some kind of indication?

FIONA What do you mean?

Indication?

JOYCE How long are you planning to stay, Fiona?

Is it weeks?

Months?

FIONA Look I'm not just thinking about me here, alright

Your family need a place to stay

A nice place and you have it

So, can we not argue about how long things are going to take

Because we have to think about Granny now too

JOYCE *Granny?*

FIONA Yes.

If she comes out of hospital

She's going to need somewhere to live

JOYCE What's wrong with her own place?

FIONA Don't be silly Mother

She needs looking after

She'll need care

JOYCE Put her in a home.

FIONA No!

What?

Jesus no that's cruel

JOYCE It's not.

FIONA She's your *mother*!

JOYCE But who's gonna look after her?

You'll be out at work or looking after the baby and Graham well...

That just leaves me, doesn't it?

FIONA And this is exactly why I'm asking you to consider a few small renovations.

I don't want you heaving Granny up and down the stairs.

Getting her up to bed, dragging her to the toilet.

Pause.

And if we get this stuff done now, for Granny

Then you won't have to worry when it's your turn

JOYCE *My* turn?

FIONA You're getting older too Mum…

Beat.

I think we should consider digging the basement.

JOYCE The *what*?!

FIONA It's a big project I know and it might not be ready in time for Granny

But it's a great option for you for the future.

You could have your own self-contained flat down there

You could have everything you need.

Beat.

We can do this Mum.

All live together

Three generations under one roof

That's what they do in other countries

Other countries where the people are nicer than us.

SCENE NINETEEN

JOYCE at home on the phone to CANDY. CANDY at the White Horse.

CANDY Fucking hell Joyce

Run away

Pack yer bags

That's what I'd do
You could go to
Brighton or
Eastbourne
Somewhere near the sea

JOYCE Oh, can you imagine…

Pause.

But I can't do that
Just
I can't

CANDY You could

JOYCE I couldn't

CANDY You *could*

What you afraid of?
Your family?
Your mother?
You can do what you like, you got money

JOYCE Money?

CANDY Yeah

If you got money you've got freedom
You got the means
If you don't like your life
Change your life

Beat.

JOYCE We could do it together

CANDY *Together?*

JOYCE Yes.

You could change your life too, couldn't you?
You could come with me
Brighton

CANDY No

JOYCE Why not?

CANDY Well…I gotta work for a start and Jason…

My whole life's here

JOYCE Oh that's no life

Beat.

CANDY What does that mean?

JOYCE I know how you earn a living Jane

I met a man outside the pub one night, he told me

CANDY Told you what?

JOYCE That it's not just…stripping that you do

Pause.

CANDY I don't think I wanna have this conversation

JOYCE No wait

CANDY No you wait

How I earn a living

That's nobody else's business…

When you've sorted out your own life

Then you can interfere in mine.

SCENE TWENTY

The hospital. PEARL in a hospital bed. She doesn't look well.

JOYCE Hello Mother.

PEARL opens her eyes.

I didn't recognise you.

Is it your hair?

Is that…

You've not brushed it.

PEARL makes a noise.

Would you like me to do it for you?

Pause.

Hang on

She produces a brush from her bag.

Here

She goes to brush PEARL's hair but PEARL pulls back.

What?

Don't be silly Mother it's just a bloody brush

PEARL makes a noise.

Is it the hairs?

I'll take them out

She takes her hair out of the brush.

I don't suppose there's a bin…

She tries again, pulls the brush through PEARL's hair.

PEARL winces.

Sorry

I'll be gentle

I'll go gentle

She brushes softer this time.

Silence then.

What do you get up to here then?

Pause as she brushes.

Do they let you watch television?

You'll have missed your favourites I expect

I haven't been keeping up with the soaps so I can't
 fill you in.

I watched *Crimewatch*

That was on the other night

You like that one don't you?

It was one of those specials

Unsolved cases the police…

You know the sort

This one was right up your street

She brushes, curling PEARL's hair at the ends.

It was about a man who'd been attacking old ladies

Reaction from PEARL.

Murdering them for

Oh years and he'd got away with it.

It was only when they had his DNA that they managed to catch him.

And when the police tracked him down they found a nice house

Good job

Marriage and three kids.

His family they couldn't believe it

He'd been the perfect husband perfect dad.

PEARL makes a noise. JOYCE stops the brushing.

'Course you'd have known Mother

You'd be onto him…

JOYCE admires PEARL's hair.

That's better.

Brush goes back in the handbag.

Would you like some powder?

JOYCE reaches into her bag. Produces a compact. She gets to work on PEARL's face.

You have beautiful skin Mother

Want some lipstick?

JOYCE rummaging around for lipstick.

Not really your colour this

Bit red, bit bright

But it's new

I bought it the other day

She takes the top off the lipstick. Rolls the stick up. Stops.

She looks at PEARL. She applies the lipstick.

Fiona didn't like it

Fiona thinks she knows me

Well she doesn't

She knows me as her mother

But beyond that

I suppose it's the same with you and me

Things you did before I came along

Things that make you you

But I don't know anything about that do I

Suppose I could ask you, get to the bottom of it but then

I'm not really that interested.

Maybe, when it comes down to it

We all just want to be strangers.

She's finished with the lipstick.

There, lovely

I've come to say goodbye Mother

PEARL makes a noise.

Oh, what?

You worried what'll happen to you?

Well, you can always go into a home.

You always said that's what you wanted didn't you?

Maybe Fiona can find you a half decent one

PEARL makes a noise again.

Oh don't get upset Mother

It won't be any worse than the place you had lined up for me

PEARL freezes.

Oh yes…you remember that don't you?

I can still see them.

Three of them

Stood in our front room

Feet stuck on the fireside rug.

Ambulance outside

'Get married Joyce'

'Get married to Vera's son or I'll have you taken
 away'

PEARL makes a noise.

What's wrong Mother?

Is something wrong?

PEARL attempts to move. JOYCE moves into her.

I didn't belong in that hospital

I wasn't mad Mother

I was YOUNG

I still am.

Pause.

I have to go now.

JOYCE goes to kiss PEARL.

She waits a beat then kisses her.

*The opening bars of 'Dear Lord and Father of Mankind'
begin.*

A congregation sings as we go into a funeral.

*An orderly enters. He wheels off PEARL as the music to 'Dear
Lord and Father of Mankind' starts. FIONA, GRAHAM,
guests and finally JOYCE enter dressed in black. They sing.
During the hymn JOYCE starts to make a noise.*

*Quiet at first but growing louder. The others start to turn
round and look at her. Is she crying? Or is she laughing?
As the sound from JOYCE gets bigger FIONA grabs her by the
arm. Holds her up. JOYCE stops. Everyone keeps singing.*

SCENE TWENTY-ONE

JOYCE's house. After PEARL's funeral. FIONA and GRAHAM are dressed in black. GRAHAM sips sherry.

GRAHAM It was a nice service

What she would have wanted

Formal…

Reverent…

Long…

I think we sang every verse of that last hymn.

FIONA We need to go home

There's still packing to do before tomorrow

GRAHAM Does Joyce know about tomorrow?

Does she know you've booked the van?

FIONA Yes of course

GRAHAM Well you'd think

She'd have said something

Make a comment or

FIONA It's not like this has been a regular week, has it Graham?

GRAHAM No but…

Are you sure she's fully aware of what's going on?

FIONA Of course she's 'fully aware'

GRAHAM What was that all about in church then?

FIONA *What?*

GRAHAM At the start…

It sounded like she was laughing

FIONA She was *crying*

Anyway, she seems alright now

Beat.

The timing is unfortunate

I'll give you that

But I didn't know Granny was going to die when I
 booked Pickfords

GRAHAM It's sort of…

Better

In a way isn't it?

You know, that Pearl…

FIONA Died?

GRAHAM Yeah.

Beat.

It would have been a lot of work…

FIONA I loved my Granny

I wanted her here, with us

I would never have put her into a home never

Not when Mum has the space here.

Beat.

I better phone Joanne

Check on the kids

We need to talk to Mum too

Work out the logistics for the next few weeks

Once we've moved in

The work starts

GRAHAM Well let's get moved in first

FIONA But there's things we need to discuss

Beat.

GRAHAM Money?

Pause.

FIONA I need a deposit before the builders can start.

GRAHAM Well be careful.

Remember she's just buried her mother

FIONA And I've just buried my grandmother

Two funerals in six months…

GRAHAM You sound like just Pearl

FIONA Aw, bless her…

JOYCE enters.

GRAHAM Hello Joyce

All the clearing up done?

I was just coming to help

JOYCE It's alright Graham

I've done it.

FIONA Sit down Mum

GRAHAM Sherry?

JOYCE No

Thanks dear

Pause.

FIONA We need to talk about tomorrow

JOYCE Tomorrow.

FIONA It's the move tomorrow

GRAHAM Had you forgotten?

We wouldn't blame you

What with all

JOYCE No

No

I hadn't forgotten

FIONA Good

Well

Graham is going to start moving small items from
our place

Bring them over here first thing

Then the removal firm will take the furniture

We're going to need someone to be here for when
they turn up so…

Could that be you?

JOYCE Me?

FIONA Yes tomorrow.

You stay here and we'll organise things our end.

JOYCE I won't be here tomorrow

FIONA Won't be here?

JOYCE No

FIONA Where will you be?

Pause.

JOYCE I'm going away

GRAHAM Away?

JOYCE Yes Graham

GRAHAM What, like a holiday?

JOYCE No.

Not exactly

FIONA Because this is no time for a holiday Mum

JOYCE It's not a holiday.

Pause.

I'm going away for good

I've booked my ticket

GRAHAM Ticket?

To where?

Pause.

JOYCE Argentina

GRAHAM Argentina?

FIONA *Argentina*!

JOYCE It's in South America

FIONA I know where it is!

JOYCE I tried to think of all the places I wanted to visit
 I had a list.
 India, America and then I thought sod it
 I'll just close my eyes and point to the map
 Wherever it lands that's where I'm gonna go

GRAHAM And it landed in *Argentina*?

JOYCE Well no
 It landed in the ocean
 I just moved it to the nearest bit of dry land

FIONA Mother you are not going to Argentina on the day
 we move in

JOYCE I am

FIONA Don't be ridiculous

JOYCE Why is it ridiculous?

FIONA You can't travel
 Half-way around the world at your age.

JOYCE *My* age?

FIONA *Yes*

JOYCE Do you know who else is *my* age?
 Paul McCartney

FIONA What?

JOYCE And Billy Connolly
 And Harrison Ford
 Jean Shrimpton
 I looked them up.

FIONA Mum I don't understand

JOYCE Aretha Franklin she's the same age as me
 Bet she's been to Argentina

FIONA But you are NOT Aretha Franklin
 Look at you.

You're just…

JOYCE What?

FIONA MY MOTHER!

Pause.

JOYCE Every day for the last forty years

I've worn a mask

You won't have noticed

But over the years it's got tighter and tighter

It started out soft.

I could just about move and speak

But it was always difficult to breathe…

It started to go hard when you were born

I thought it was set for good

But on the day your father died

It began to chip

Tiny flecks, flaking off

The first time I noticed I was in a restaurant

I went to a restaurant on my own

Michelin star restaurant

There were bits floating in my soup,

I was going to tell the waiter, make a complaint

I mean you don't expect things floating in your
soup in Michelin starred restaurants

But then I realized…

It was me.

Bits of me

Shedding

Ever so ever so

Slowly.

When I finally leave this house, the last bits will fall
away

So by the time I sit on that plane you won't even
 recognise me

You won't know who I am.

FIONA No, you're my mother and you've gone mad

GRAHAM I need another drink

FIONA What have you got to run away from?

You've got a great life here

A nice house, family that love you

JOYCE I've got one life

I want another one

FIONA How much is this going to cost?

JOYCE Well I've budgeted for 22,000 a year

GRAHAM A *year*?

FIONA For how many years?

JOYCE I don't know

But if things get tight I can always go to Thailand

You can live in Thailand on six pounds a week

GRAHAM Actually Thailand's great

It's a lot nicer than South America

FIONA Oh shut up Graham!

God I would kill to have had your life Mother

We have nothing

Compared to you and Dad I would actually say we
 were POOR

JOYCE Oh yes money, what you haven't got

It's all you think about

FIONA Yes Mum it is

Right now it is all we think about

JOYCE You made money but you spent it

Now I'm going to spend mine

FIONA No no no

You go if that's what you want Mother, no

You go off round the world like some sulky
 teenager

Don't come back or do come back I don't care

I'll do the renovations on this house

Get this place into some kind of order

I can cope

I always do.

JOYCE I'm afraid you can't move in.

Beat.

FIONA What?

JOYCE You can't move in.

FIONA Don't be silly Mother what do you mean we can't
 move in

We have nowhere else to go

Don't mess me about

JOYCE I'm sorry.

But this isn't my house anymore.

FIONA What do you mean not *your* house?

GRAHAM What have you done?

FIONA Shush!

JOYCE I wanted to leave with nothing.

That was my plan.

So, I went to a solicitor

GRAHAM What solicitor?

JOYCE It's all legal

It's all done and dusted.

FIONA Mother, what have you done?

JOYCE I've given this house to someone who really needs it

FIONA Given?

What does that mean given?

GRAHAM Shit, you haven't *sold* it?

JOYCE No.

No

GRAHAM Thank God for that

JOYCE I've gifted it

FIONA *Gifted?*

JOYCE To charity.

A charity of my choosing

FIONA You're making this up

JOYCE I'm not.

GRAHAM You're not serious Joyce?

You haven't given the house away?

JOYCE You need to stand together Graham

As a family

You and Fiona

You need to take responsibility for your own lives

FIONA Mother

JOYCE The house goes.

I leave, you don't have to worry about me anymore

I am doing you a favour

FIONA *A favour?*

JOYCE If you'd moved in here you would never have been satisfied.

The cravings that are inside you

And you know they are inside you, they would never have stopped.

Then you'd have passed that onto your children and then their children.

GRAHAM But you can't just leave us without a home Joyce

JOYCE You had a home Graham

You lost it

You can't have this one

GRAHAM What's the name of this solicitor?

FIONA We can't let her do this

Can she do this?

JOYCE It's my house

FIONA There'll be laws

Court orders or –

When Dad died he left you everything

Because he trusted you to leave it to me not give it away to charity.

If he was here now

If he could see this

JOYCE Well he's not here

He's dead

I'm sure you wish he wasn't.

I'm sure you wish I was.

I'm not doing this out of spite Fiona.

I'm doing this for both of us.

From now on I don't owe you

You don't owe me.

GRAHAM She's pregnant Joyce

And the kids!

Where do we go?

Beat.

JOYCE Well there's always Granny's flat…

FIONA I'm gonna get a doctor in

A psychiatrist

Prove she's fucking mad!

JOYCE Oh you can do what you like

I'll see any doctor in town.

You only have to take one look at me to say I'm
 perfectly sane

SCENE TWENTY-TWO

*Six months later. JOYCE's empty house. CANDY enters.
She carries a cardboard box. On her shoulder she carries a
holdall. She drops the holdall. Puts down the box. Looks
around. Smiles. Starts unpacking the box. It contains books.*

End.

BY THE SAME AUTHOR

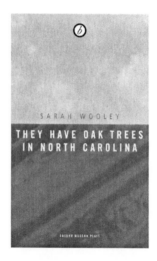

They Have Oak Trees in North Carolina
978-1-84002-818-8

Ray and Eileen's five-year-old son vanishes on a family holiday to Florida. Twenty-two years later, a good-looking American arrives in their sleepy English village and claims to be their boy. Can this man really be their missing child, or is he an impostor? And what long buried secrets will have to be revealed to prove his true identity?

WWW.OBERONBOOKS.COM

Follow us on www.twitter.com/@oberonbooks
& www.facebook.com/oberonbook